Patterning Techniques

A pattern is a repetition of shapes and lines that can be simple or complex depending on your preference and the space you want to fill. Even complicated patterns start out very simple with either a line or a shape.

Repeating shapes (floating)

Shapes and lines are the basic building blocks of patterns. Here are some example shapes that we can easily turn into patterns:

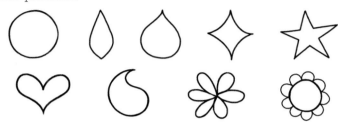

Before we turn these shapes into patterns, let's spruce them up a bit by outlining, double-stroking (going over a line more than once to make it thicker), and adding shapes to the inside and outside.

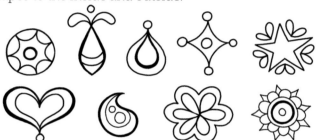

To create a pattern from these embellished shapes, all you have to do is repeat them, as shown below. You can also add small shapes in between the embellished shapes, as shown.

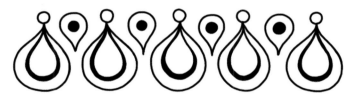

These are called "floating" patterns because they are not attached to a line (like the ones described in the next example). These floating patterns can be used to fill space anywhere and can be made big or small, short or long, to suit your needs.

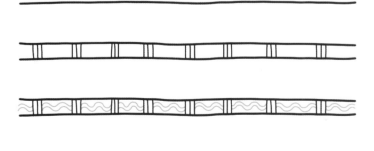

> ## Tip
>
> Draw your patterns in pencil first, and then go over them with black or color. Or draw them with black ink and color them afterward. Or draw them in color right from the start. Experiment with all three ways and see which works best for you!

> ## Tip
>
> If you add shapes and patterns to these coloring pages using pens or markers, make sure the ink is completely dry before you color on top of them; otherwise, the ink may smear.

Repeating shapes (attached to a line)

Start with a line, and then draw simple repeating shapes along the line. Next, embellish each shape by outlining, double-stroking, and adding shapes to the inside and outside. Check out the example below.

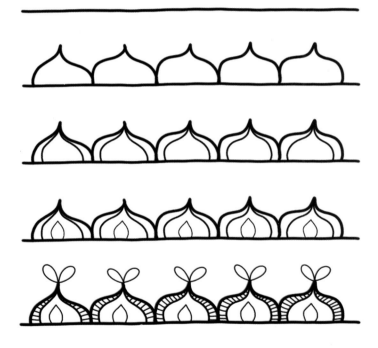

You can also draw shapes in between a pair of lines, like this:

Embellishing a decorative line

You can also create patterns by starting off with a simple decorative line, such as a loopy line or a wavy line, and then adding more details. Here are some examples of decorative lines:

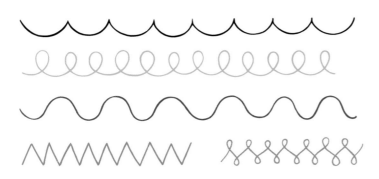

Color repetition

Patterns can also be made by repeating sets of colors. Create dynamic effects by alternating the colors of the shapes in a pattern so that the colors themselves form a pattern.

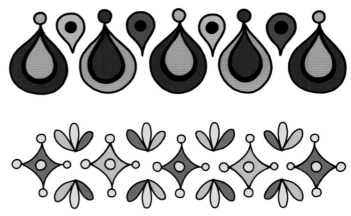

Next, embellish the line by outlining, double-stroking, and adding shapes above and below the line as shown here:

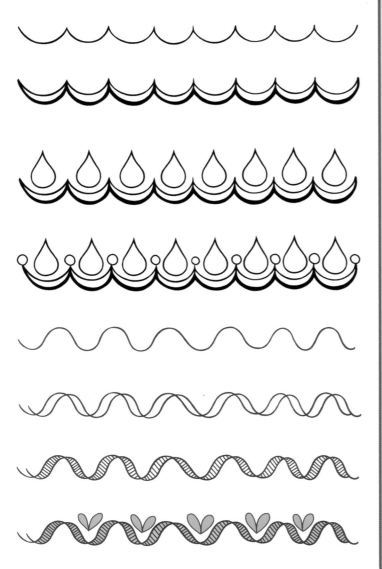

Tip

Patterns don't have to follow a straight line—they can curve, zigzag, loop, or go in any direction you want! You can draw patterns on curved lines, with the shapes following the flow of the line above or below.

These types of patterns look great when attached to the inner or outer edge of a drawing, such as the inside of a flower petal or butterfly wing.

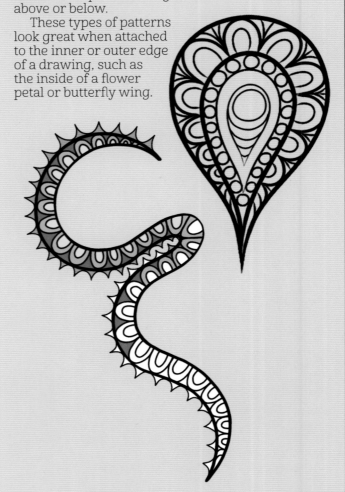

Coloring Techniques & Media

My favorite way to color is to combine a variety of media so I can benefit from the best that each has to offer. When experimenting with new combinations of media, I strongly recommend testing first by layering the colors and media on scrap paper to find out what works and what doesn't. It's a good idea to do all your testing in a sketchbook and label the colors/brands you used for future reference.

Markers & colored pencils

Smooth out areas colored with marker by going over them with colored pencils. Start by coloring lightly, and then apply more pressure if needed.

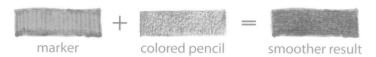

marker + colored pencil = smoother result

Test your colors on scrap paper first to make sure they match. You don't have to match the colors if you don't want to, though. See the cool effects you can achieve by layering a different color on top of the marker below.

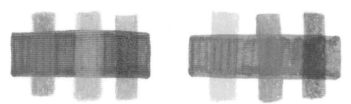

Markers (horizontal) overlapped with colored pencils (vertical).

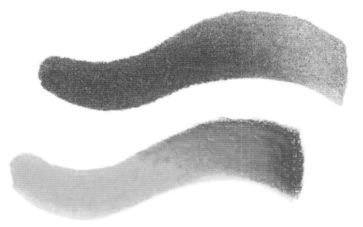

Purple marker overlapped with white and light blue colored pencils. Yellow marker overlapped with orange and red colored pencils.

Markers & gel pens

Markers and gel pens go hand in hand, because markers can fill large spaces quickly, while gel pens have fine points for adding fun details.

White gel pens are especially fun for drawing over dark colors, while glittery gel pens are great for adding sparkly accents.

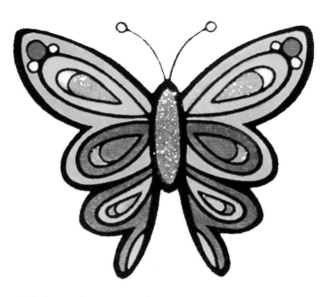

This butterfly was mostly colored with marker, but glittery gel pens were used to add sparkly accents.

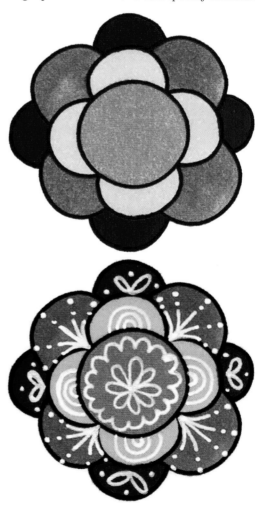

The top flower above was colored with markers, while the bottom flower has details added over top of the marker with white gel pen.

Shading

Shading is a great way to add depth and sophistication to a drawing. Even layering just one color on top of another color can be enough to indicate shading. And of course, you can combine different media to create shading.

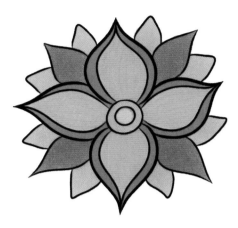

The flower on the left was colored with markers. In the flower on the right, the inner corners of each petal were shaded with colored pencil to create a sense of overlapping.

The flower on the left was colored with colored pencils. In the flower on the right, shading has been added with colored pencils.

Lines and dots were added to the flower on the left with black ink to indicate shading. In the flower on the right, color has been added over the black ink with markers.

Color Theory

One of the most common questions beginners ask when they're getting ready to color is, "What colors should I use?" The fun thing about coloring is that there is no such thing as right or wrong. You can use whatever colors you want, wherever you want! Coloring offers a lot of freedom, allowing you to explore a whole world of possibilities.

With that said, if you're looking for a little guidance, it is helpful to understand some basic color theory. Let's look at the nifty color wheel in the shape of a flower below. Each color is labeled with a P, S, or T, which stands for Primary, Secondary, and Tertiary. The primary colors are red, yellow, and blue. They are called primary colors because they can't be created by mixing other colors together. When you mix two primary colors together, the result is a secondary color. The secondary colors are orange, green, and purple (also called violet). When you

mix a secondary color with a primary color, the result is a tertiary color (also known as an intermediate color). The tertiary colors are yellow-orange, yellow-green, blue-green, blue-purple, red-purple, and red-orange.

Working toward the center of the six large primary and secondary color petals, you'll see three rows of lighter colors, which are called tints. A tint is a color plus white. Moving in from the tints, you'll see three rows of darker colors, which are called shades. A shade is a color plus black. The colors on the top half of the color wheel are considered warm colors (red, yellow, orange), and the colors on the bottom half of the color wheel are considered cool colors (green, blue, purple). Colors opposite one another on the color wheel are called complementary, and colors that are next to each other are called analogous.

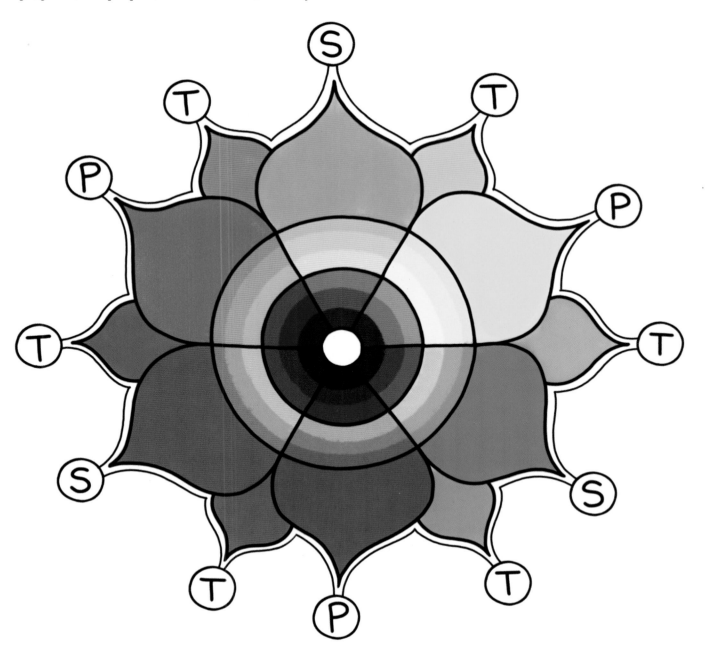

Color Combinations

There are so many ways to combine colors that sometimes it can be overwhelming to think of the possibilities...but it can also be a ton of fun deciding what color scheme you are going to use!

It's important to remember that there is no right or wrong way to color a piece of art, because everyone's tastes are different when it comes to color. Each of us naturally gravitates toward certain colors or color schemes, so over time, you'll learn which colors you tend to use the most (you might already have an idea!). Color theory can help you understand how colors relate to each other, and perhaps open your eyes to new color combos you might not have tried before!

Check out the butterflies below. They are colored in many different ways, using some of the color combinations mentioned in the color wheel section before. Note how each color combo affects the overall appearance and "feel" of the butterfly. As you look at these butterflies, ask yourself which ones you are most attracted to, and why. Which color combinations feel more dynamic to you? Which ones pop out and grab you? Which ones seem to blend harmoniously? Do any combinations seem rather dull to you? By asking yourself these questions, you can gain an understanding of the color schemes you prefer.

Now that you've evaluated some different color schemes, you're ready to start experimenting on paper. When you're getting ready to color a piece of art, test various color combos on scrap paper or in a sketchbook to get a feel for the way the colors work together. When you color, remember to also use the white of the paper as a "color." Not every portion of the art piece has to be filled in with color. Often, leaving a bit of white here and there adds some wonderful variety to the image!

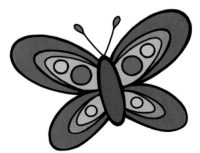

Warm colors

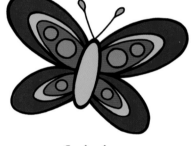

Cool colors

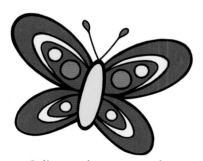

Warm colors with cool accents

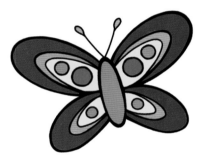

Cool colors with warm accents

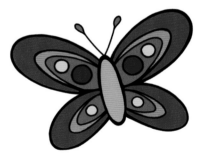

Tints and shades of red

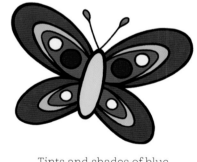

Tints and shades of blue

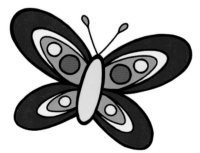

Analogous colors

Complementary colors

Split complementary colors

Color by Catherine Ryan.

Color by Catherine Ryan.

Color by Kate Lanphier.

Color by Kati Erney.

Color by Kati Erney.

Color by Melissa Younger.

Color by Cindy Fahs.

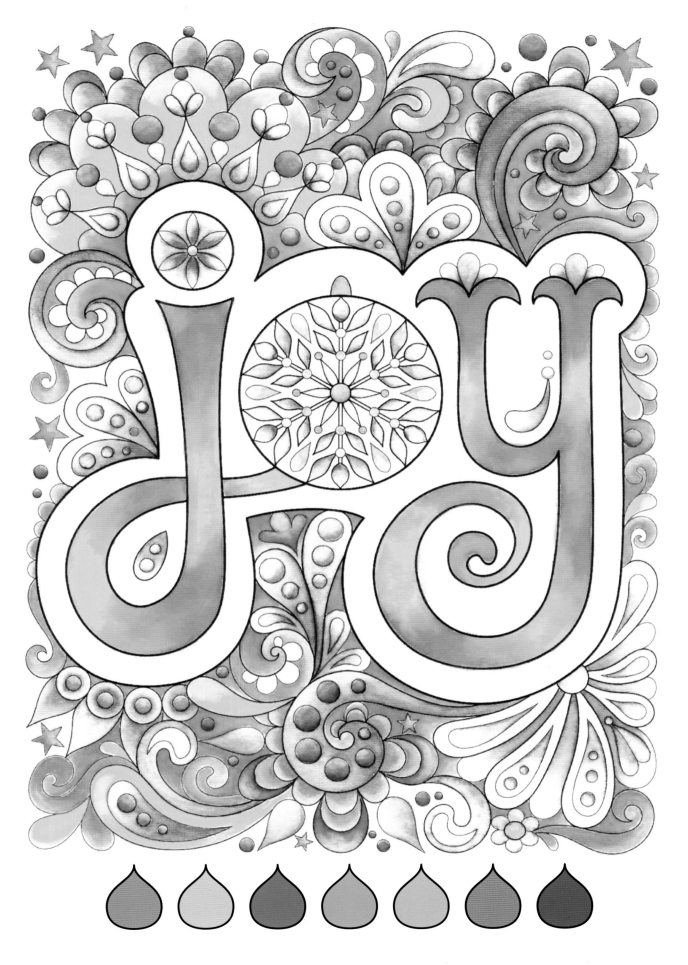

Color by Ranae Davidson.

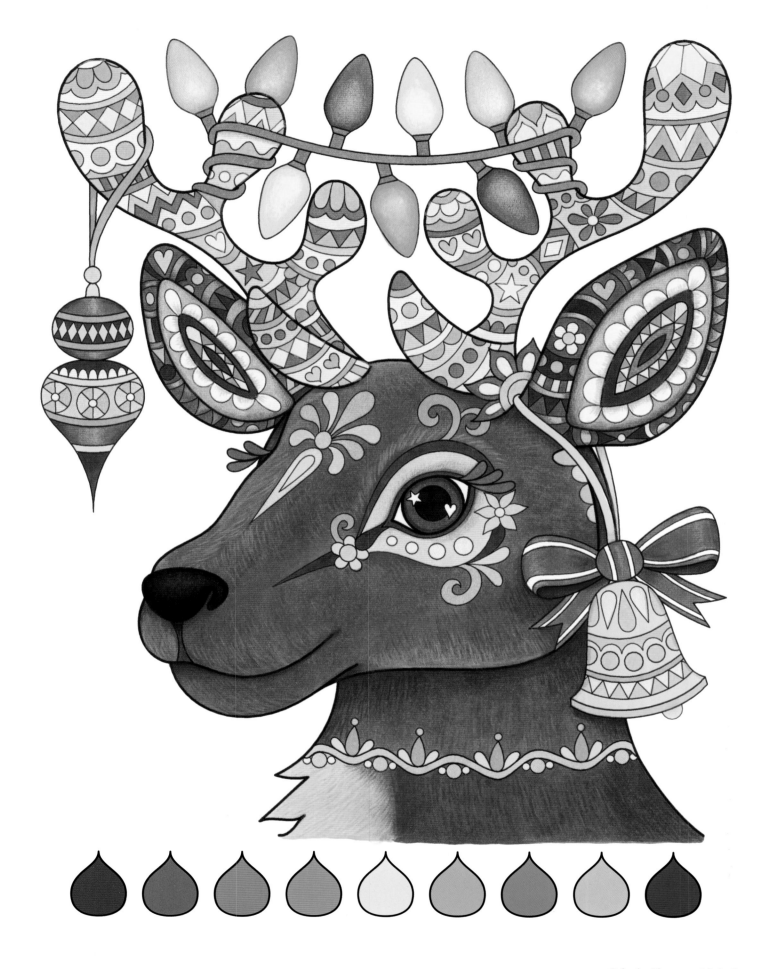

Rudolph with your nose so bright,
won't you guide my sleigh tonight?

—Rudolph the Red-Nosed Reindeer

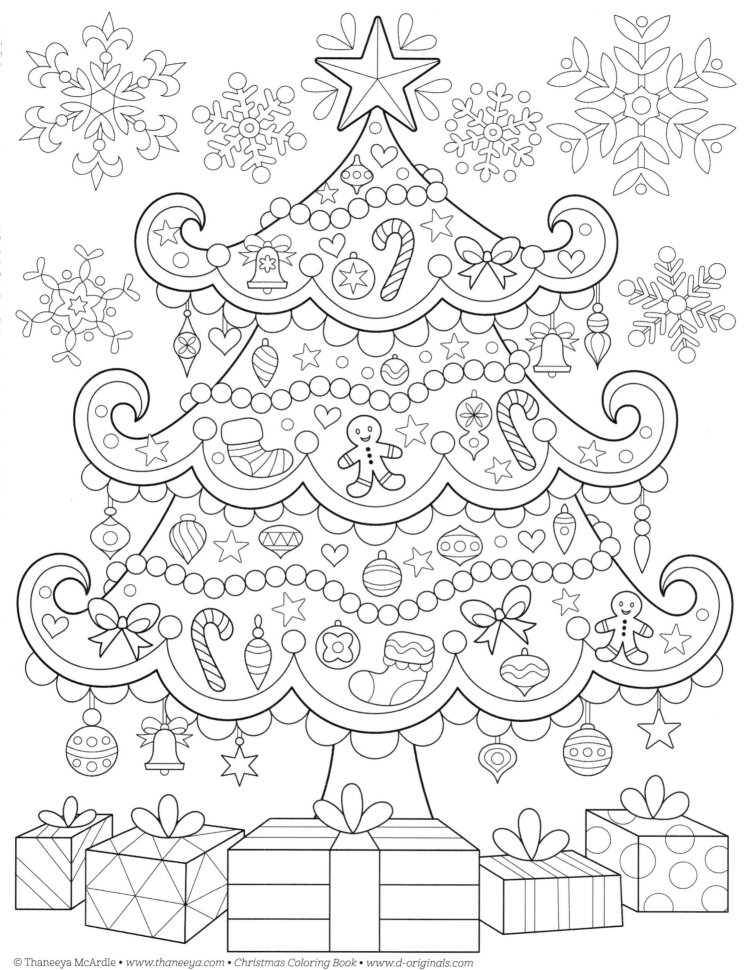

One of the most glorious messes in the world is the mess created in the living room on Christmas day. Don't clean it up too quickly.

—Andy Rooney

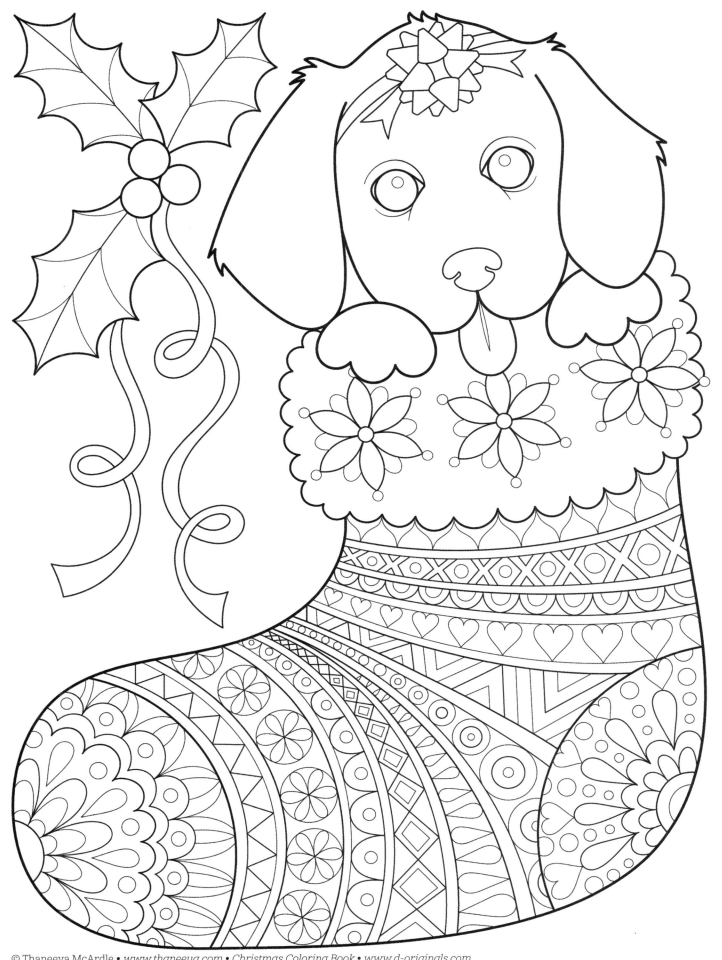

Remember, this December, that love
weighs more than gold!

—Josephine Dodge Daskam Bacon

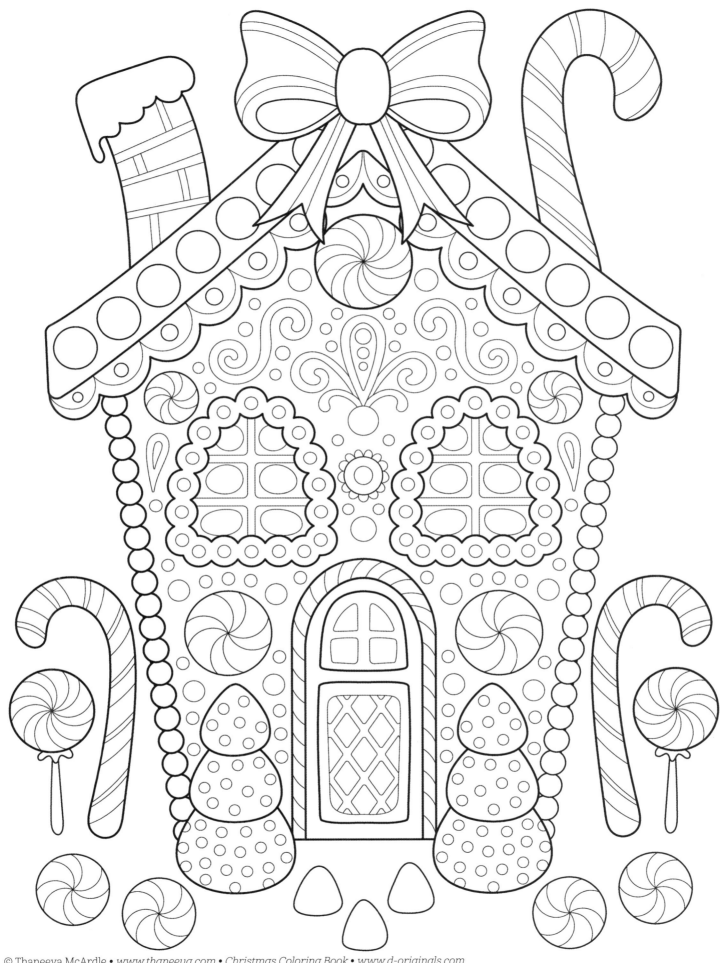

A little smile, a word of cheer, a bit of love from someone near, a little gift from one held dear, best wishes for the coming year...these make a Merry Christmas!

—Unknown

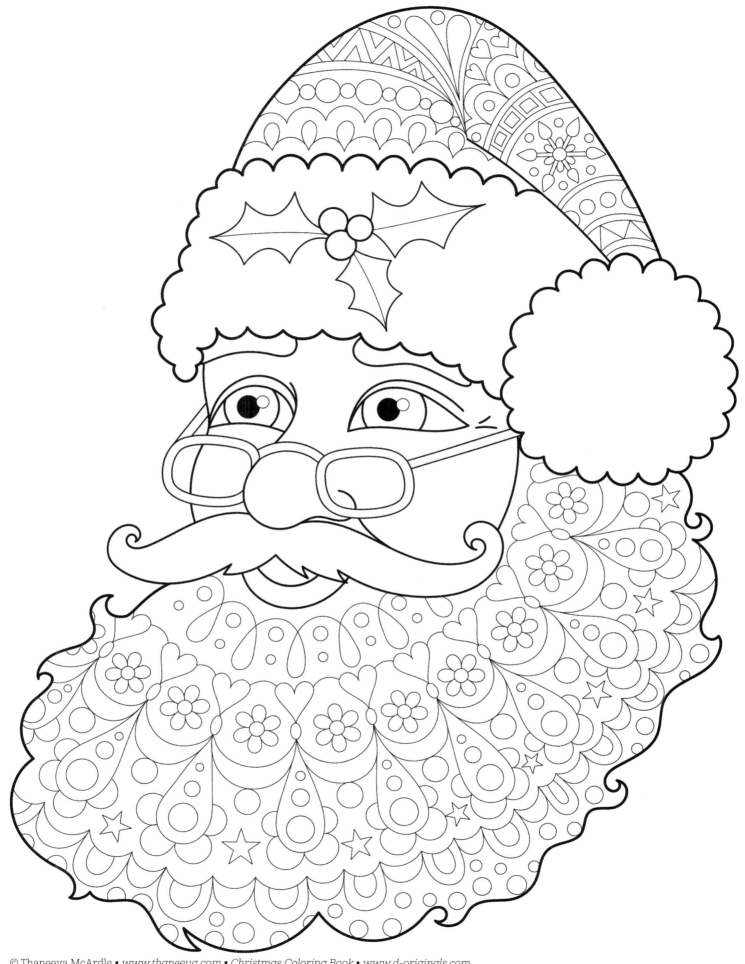

The best and most beautiful things in the
world cannot be seen or even touched.
They must be felt with the heart.

—Helen Keller

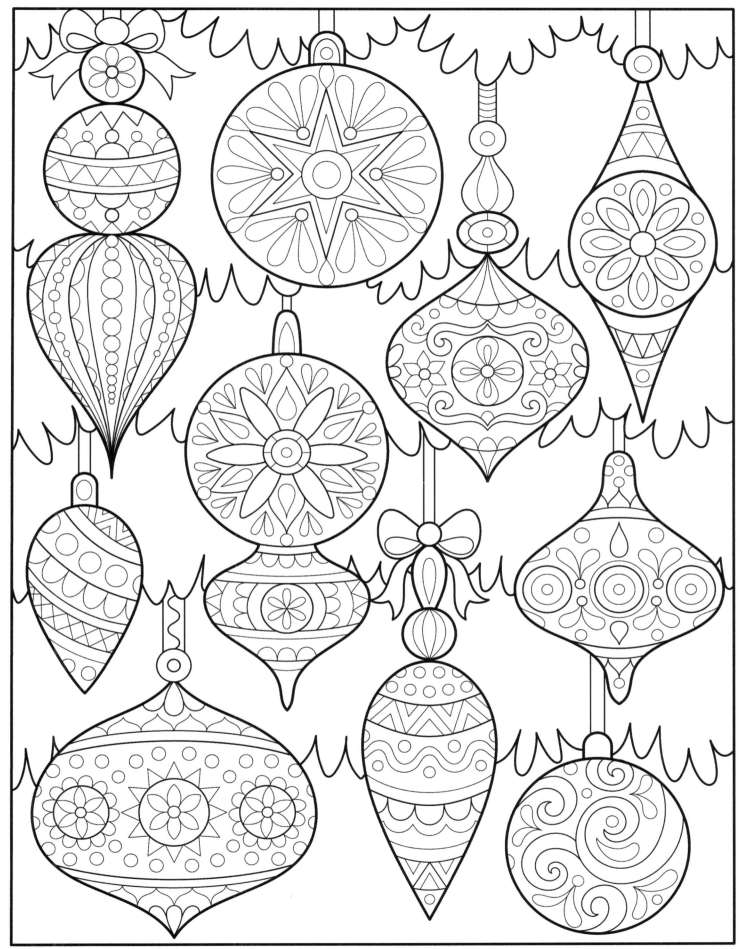

If I could wish a wish for you,
it would be for peace, faith, and happiness
not only at Christmas,
but for the whole year through!

—Catherine Pulsifer, *My Christmas Wish to YOU*

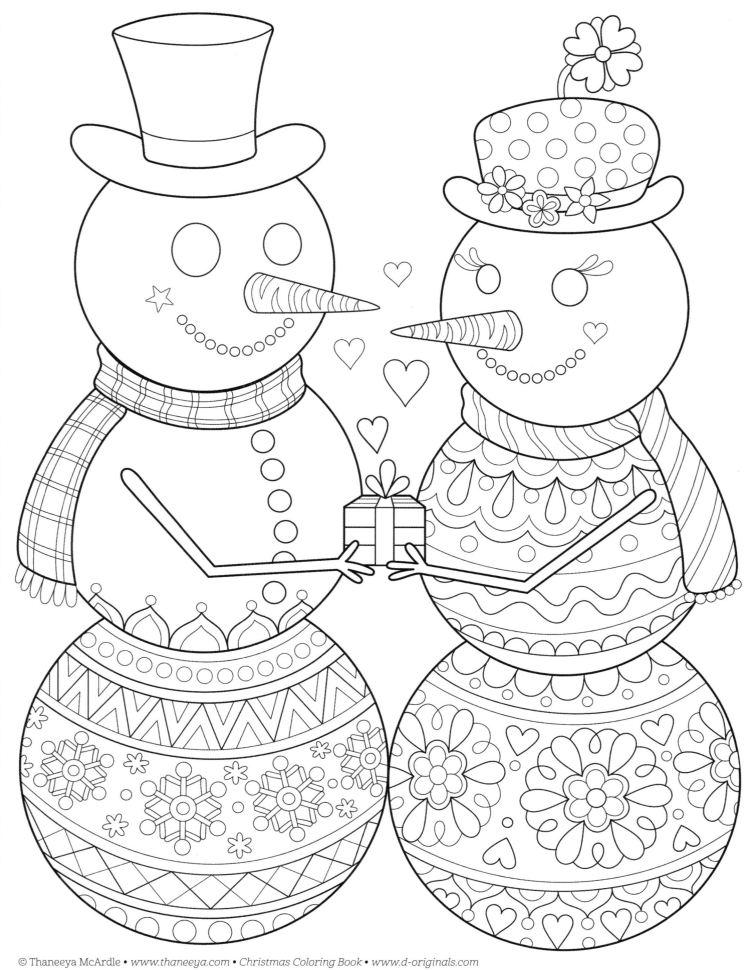

Then the Grinch thought of something he hadn't before!
What if Christmas, he thought, doesn't come from a store.
What if Christmas, perhaps, means a little bit more!

—Dr. Seuss, *How the Grinch Stole Christmas!*

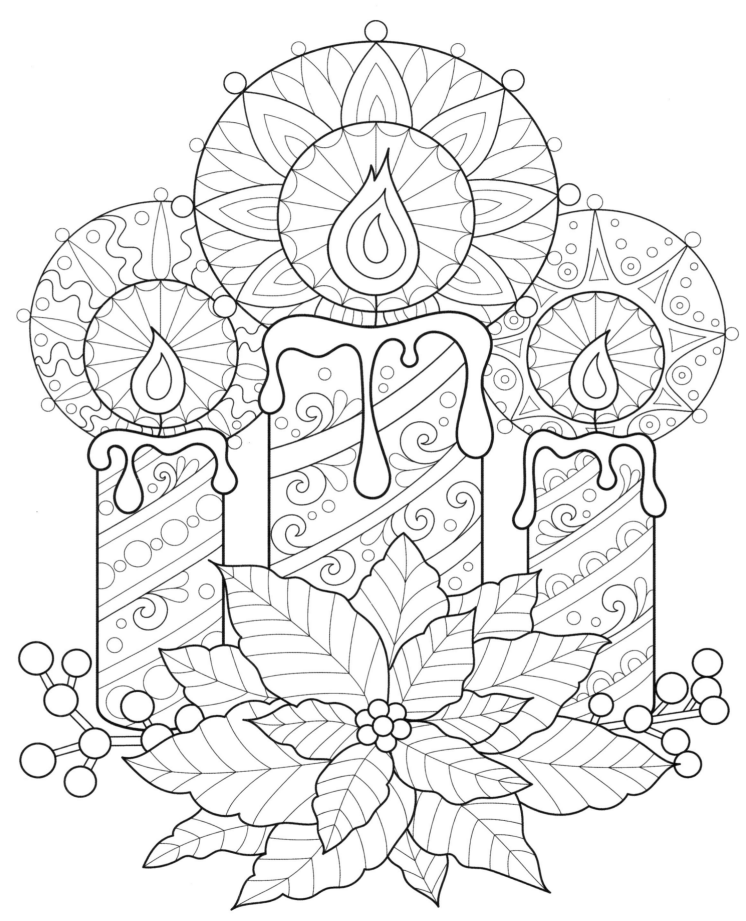

Christmas eve was a night of song that wrapped
itself about you like a shawl. But it warmed
more than your body. It warmed your heart...
filled it, too, with melody that would last forever.

—Bess Streeter Aldrich

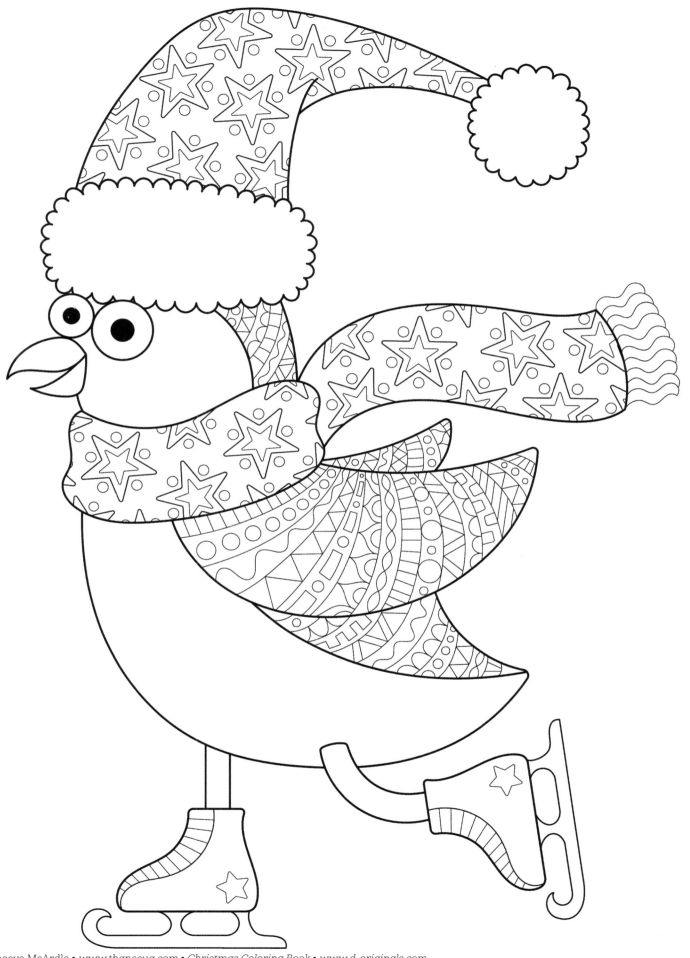

This time of year means being kind to
everyone we meet, to share a smile with
strangers we may pass along the street.

—Betty Black

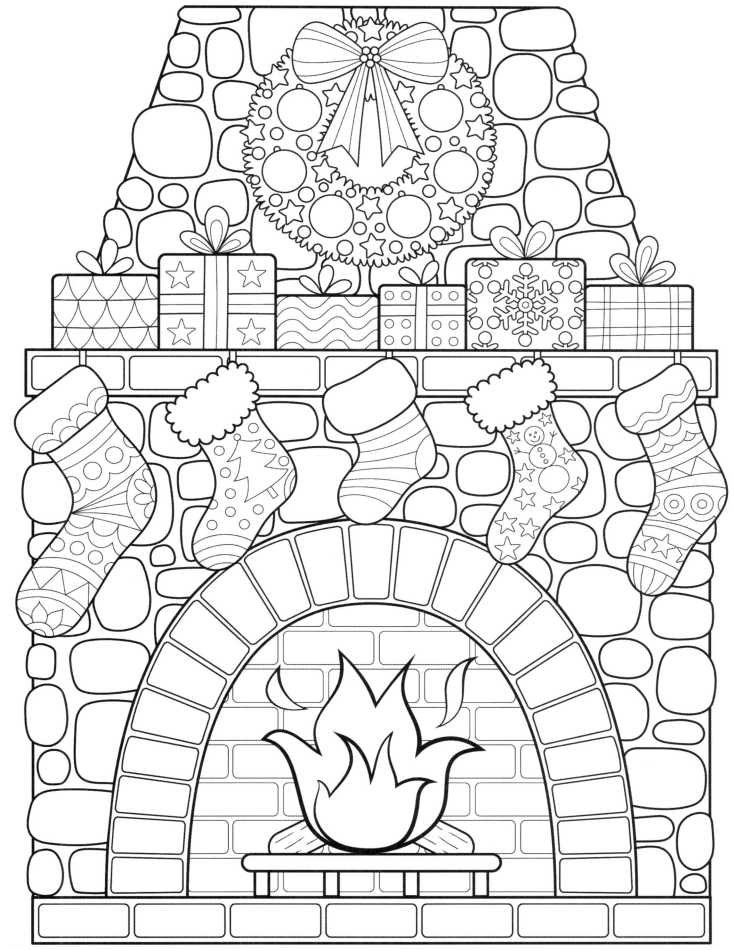

At Christmas, all roads lead home.

—Marjorie Holmes

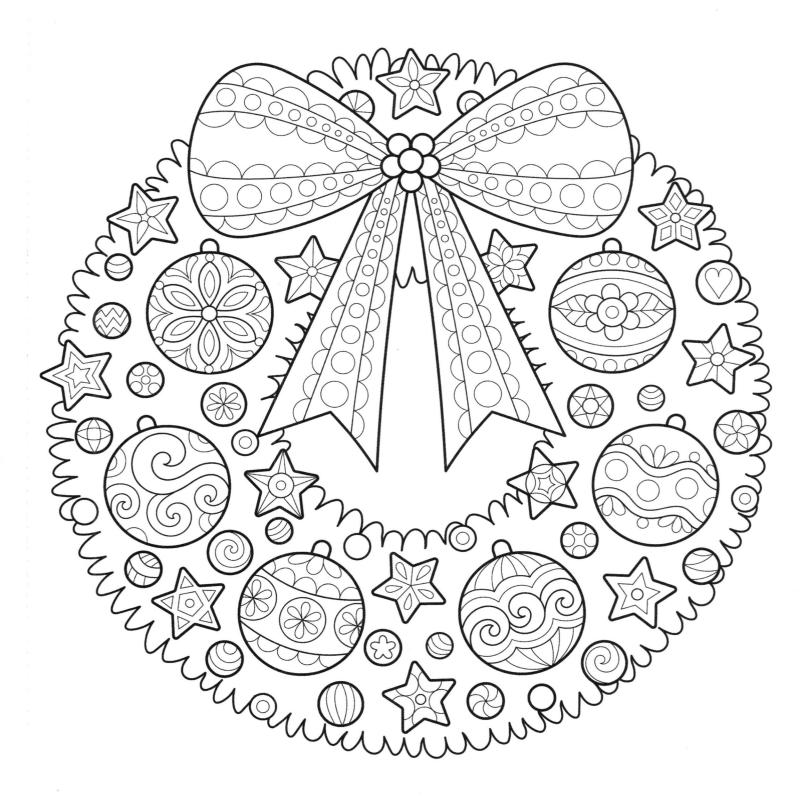

It's beginning to look a lot like Christmas,
Toys in every store,
But the prettiest sight to see
Is the holly that will be
On your own front door.

—Meredith Wilson, *It's Beginning to Look
a Lot Like Christmas*

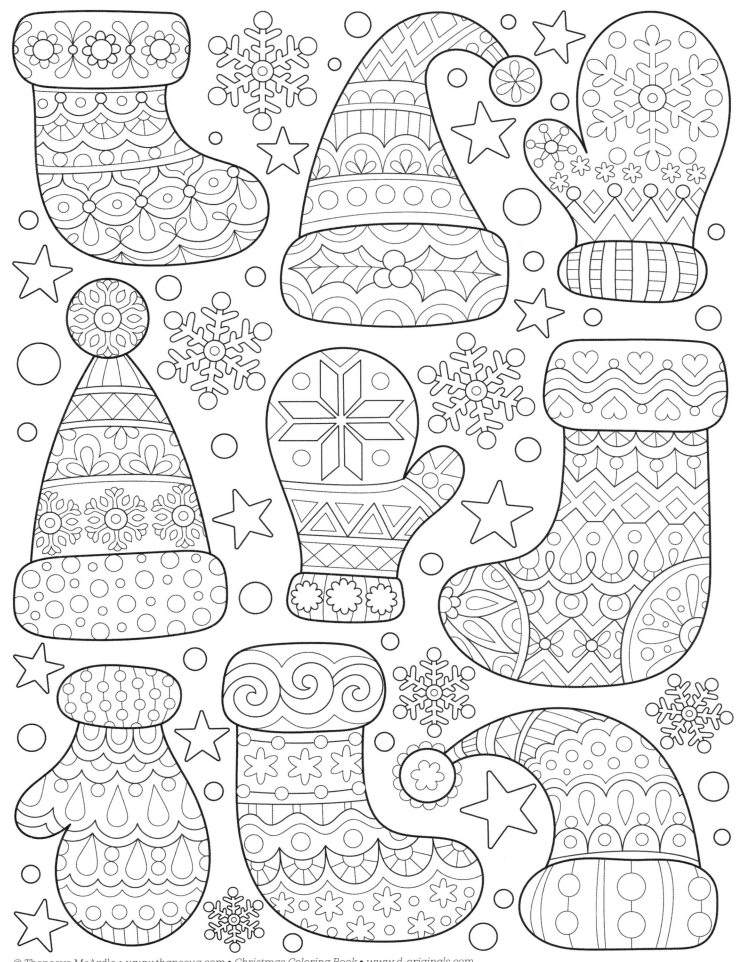

From home to home, and heart to heart,
from one place to another, the warmth
and joy of Christmas brings us closer
to each other.

—Emily Matthews

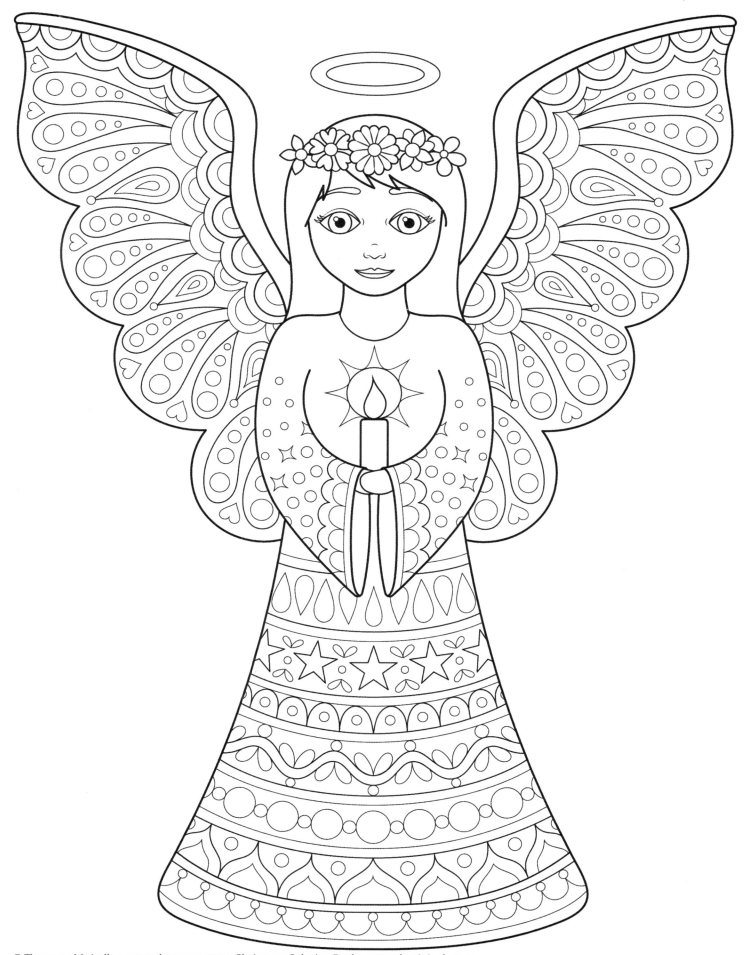

Seeing is believing, but sometimes the most real things in the world are the things we can't see.

—*The Polar Express*

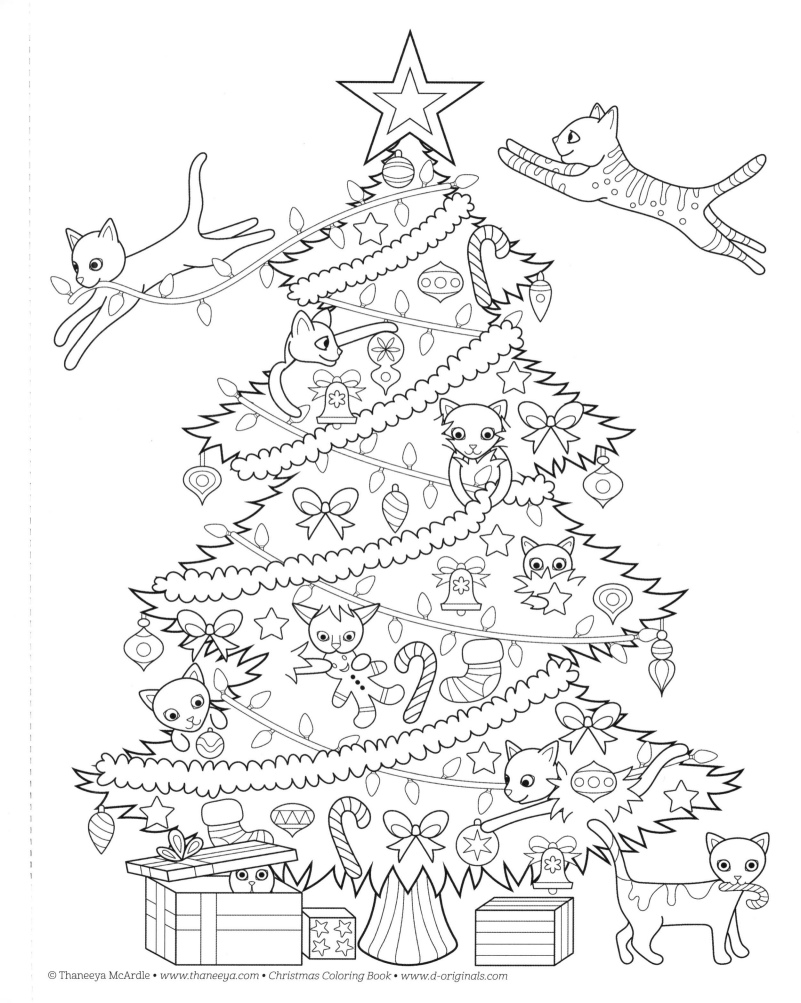

At Christmas play and make good cheer,
for Christmas comes but once a year.

—Thomas Tusser

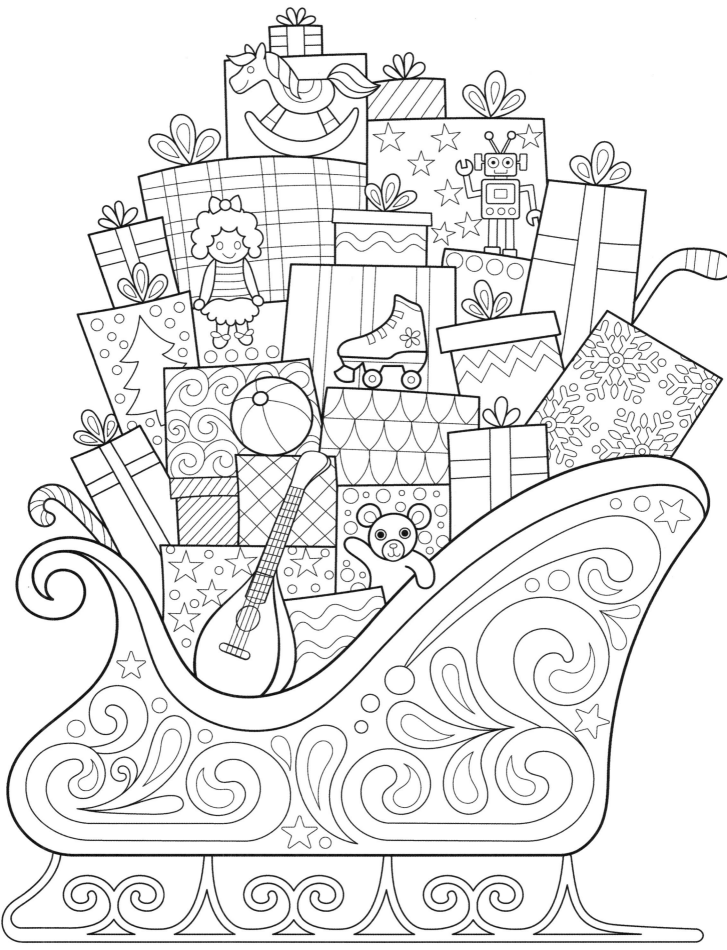

Christmas is not as much about opening
our presents as opening our hearts.

—Janice Maeditere

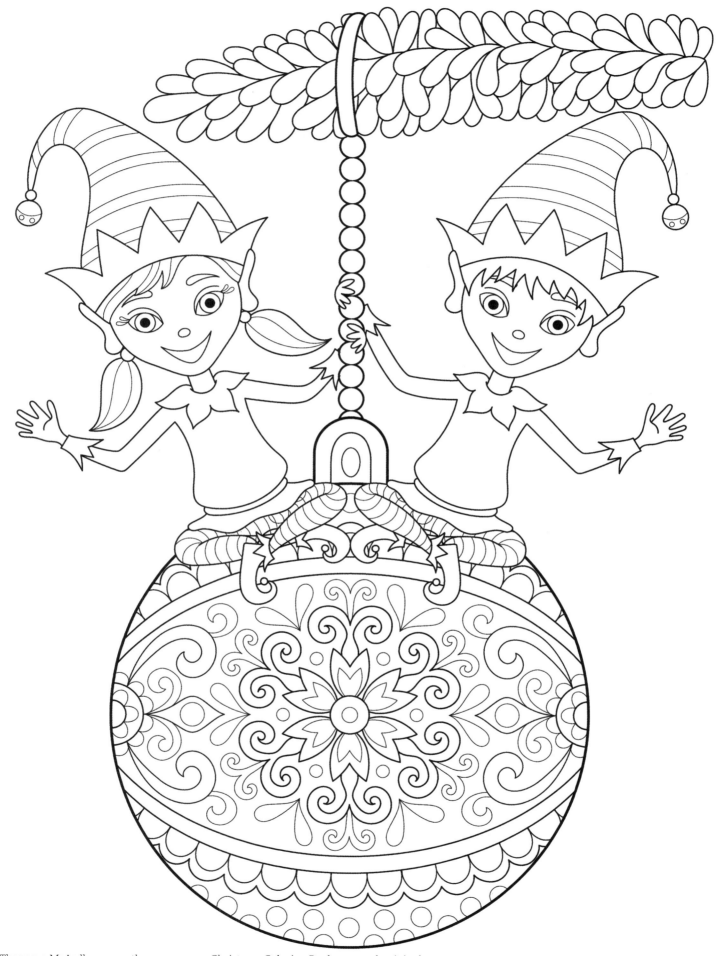

So every year when Christmas comes, I realize
anew, the best gift life can offer is having
friends like you.

—Helen Steiner Rice

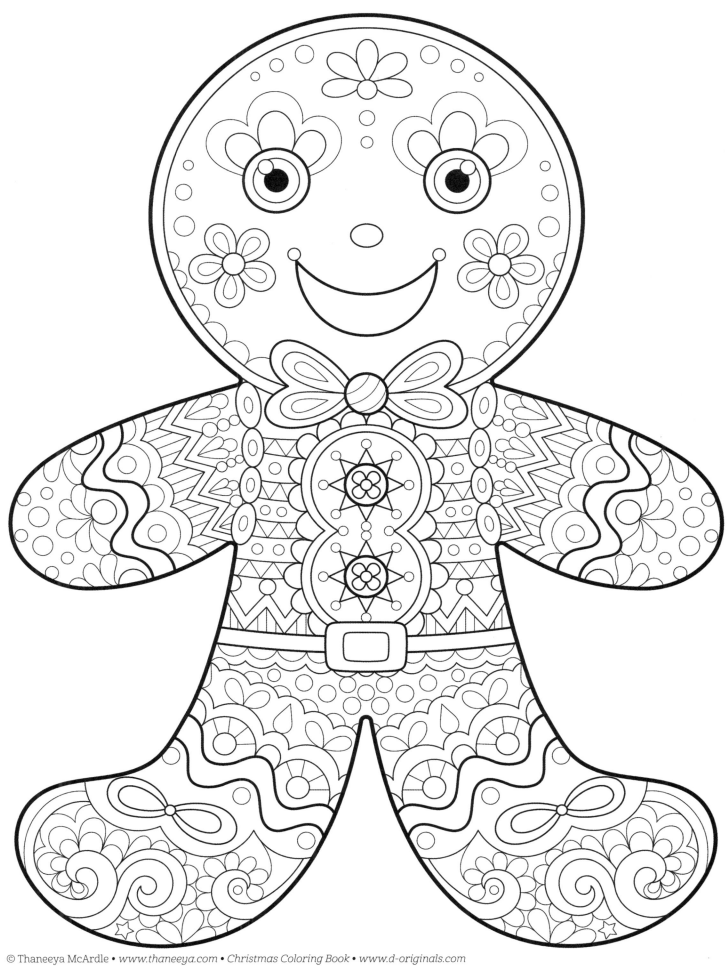

Christmas cookies and happy hearts, this
is how the holiday starts!

—Unknown

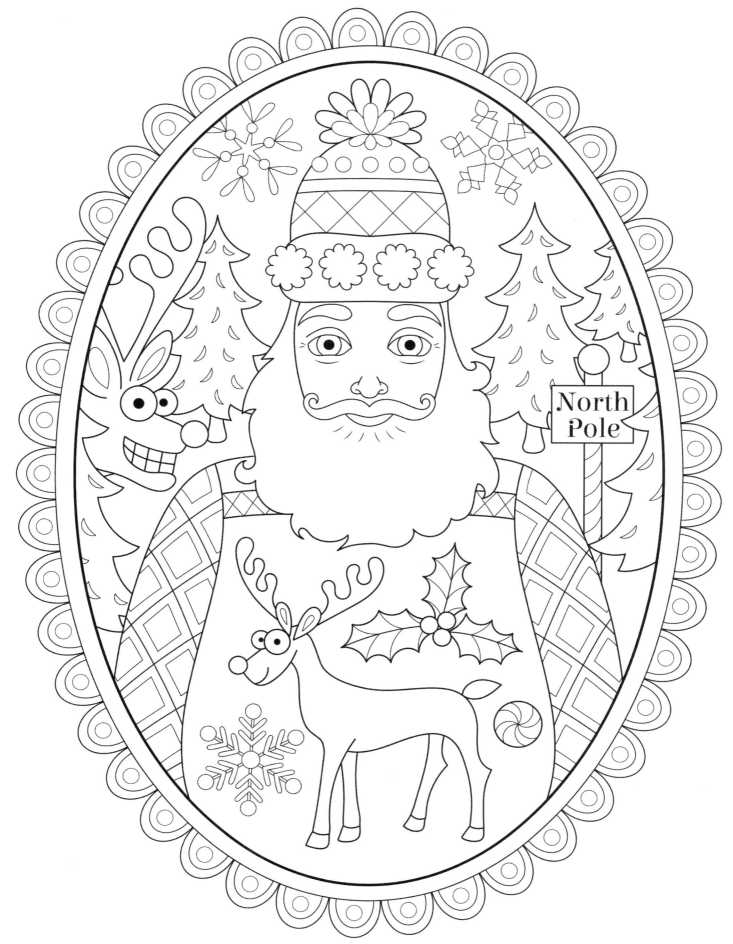

North Pole

He's making a list
And checking it twice;
Gonna find out who's naughty and nice
Santa Claus is comin' to town

—Santa Claus Is Comin' to Town

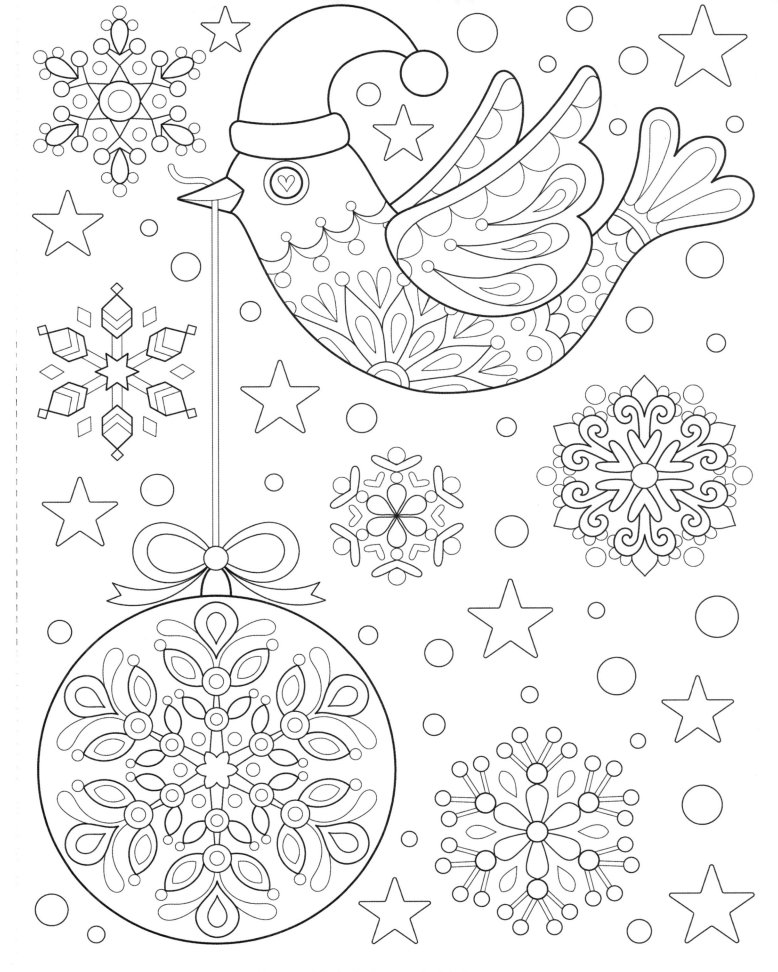

Christmas magic is silent. You don't hear
it—you feel it, you know it, you believe it.

—Kevin Alan Milne

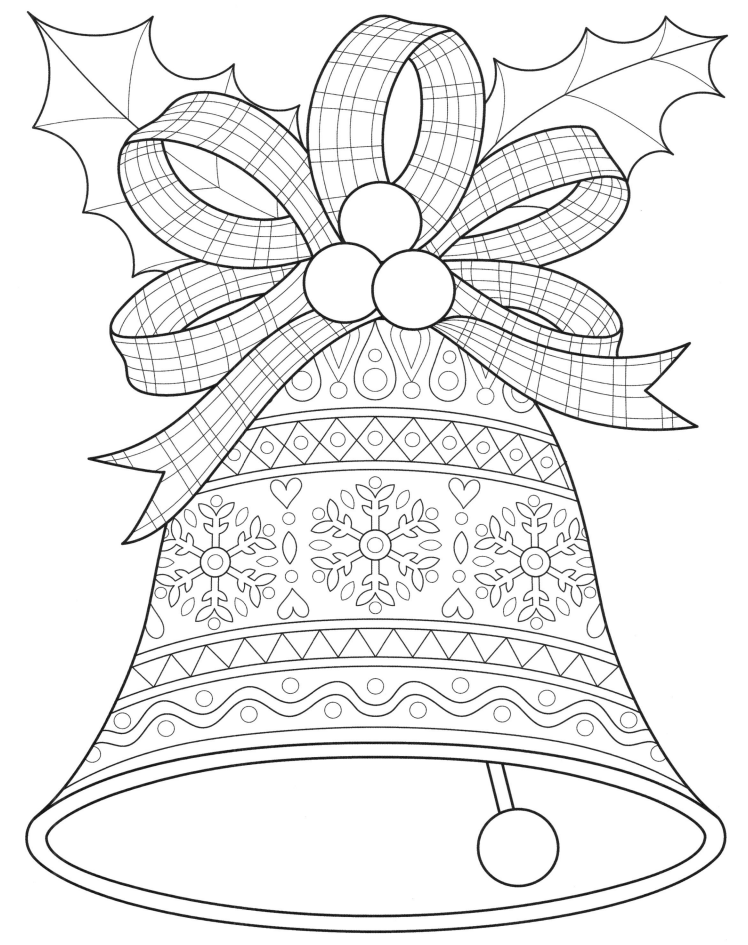

Jingle bells, jingle bells,
Jingle all the way.
Oh! what fun it is to ride
In a one-horse open sleigh.

—James Lord Pierpont, *Jingle Bells*

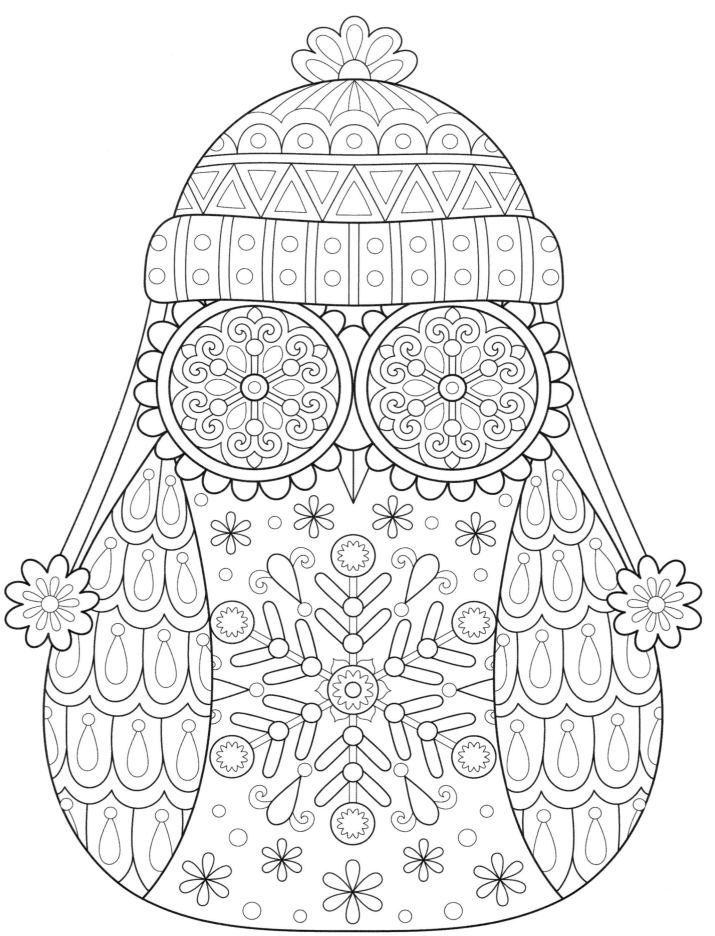

I wish we could put up some of the Christmas spirit in jars and open a jar of it every month.

—Harlan Miller

Somehow, not only for Christmas but all the
long year through, the joy that you give to others
is the joy that comes back to you.

—John Greenleaf Whittier

Deck the halls with boughs of holly,
Fa la la la la, la la la la!

—Deck The Halls

I'm dreaming of a white Christmas,
Just like the ones I used to know,
Where the treetops glisten
And children listen
To hear sleigh bells in the snow.

—Irving Berlin, *White Christmas*

Christmas is the day that holds all time together.

—Alexander Smith

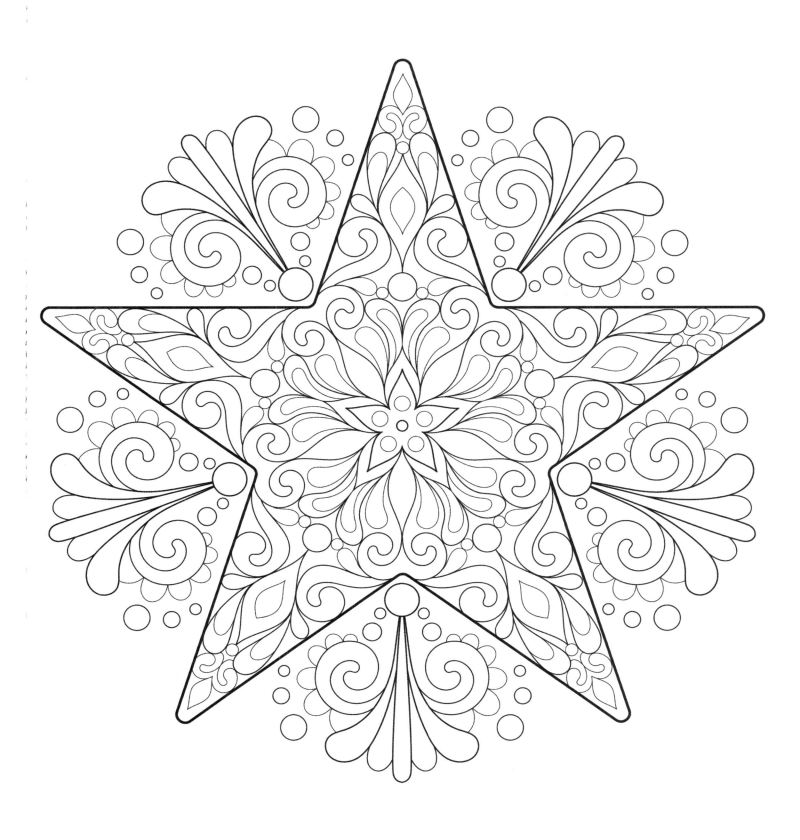

It's Christmas Eve. Good deeds count
extra tonight. Think of an important thing
you can do for others and go do it. Just
follow the star in your heart.

—Home Alone 2: Lost in New York

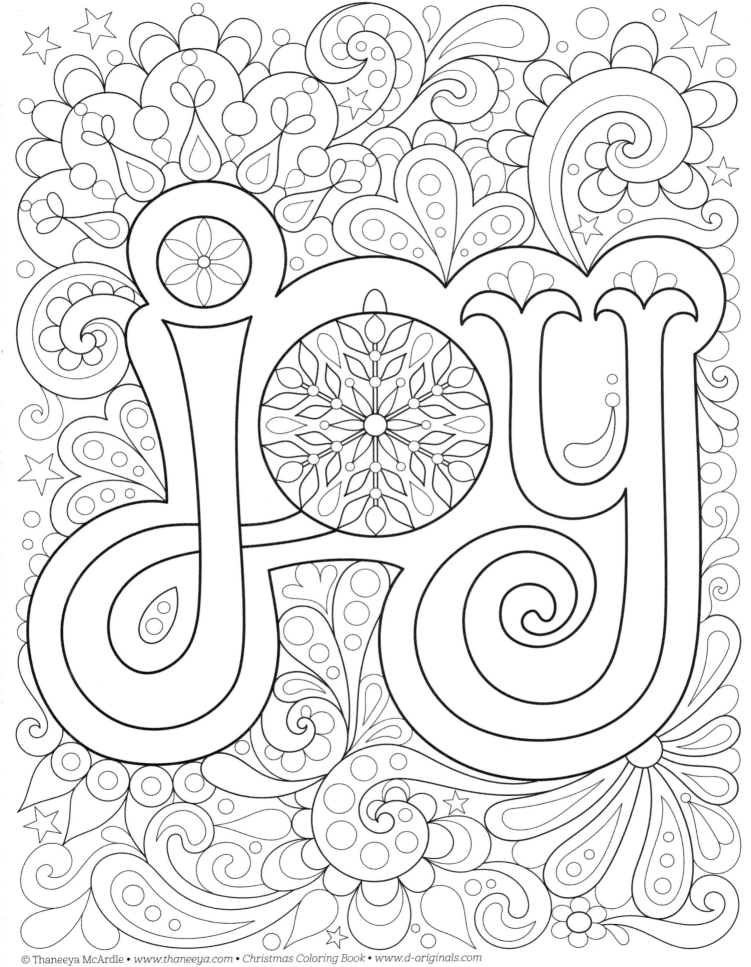

The best way to spread Christmas cheer
is singing loud for all to hear!

—Elf

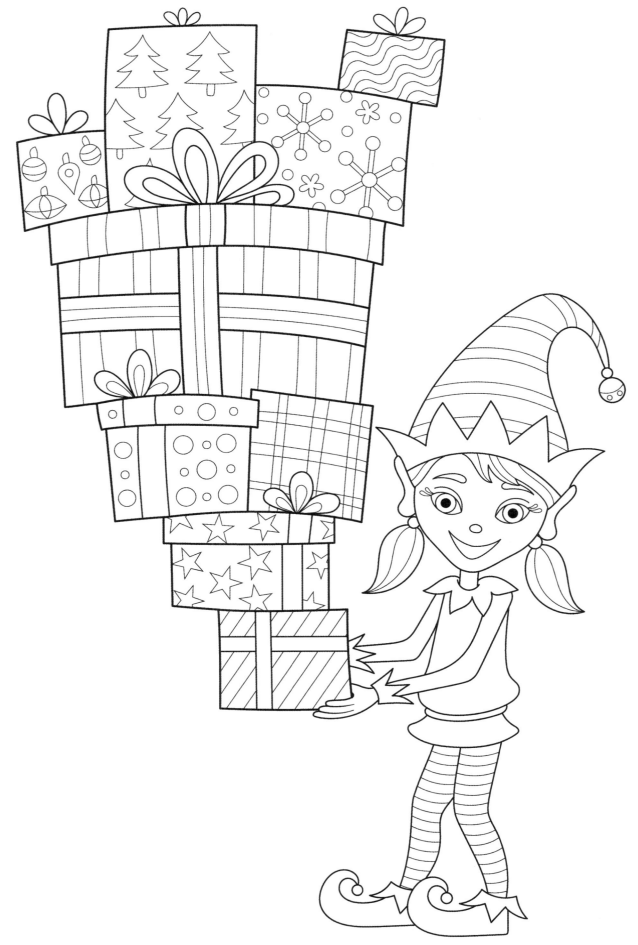

Probably the reason we all go so haywire
at Christmas time with the endless
unrestrained and often silly buying of
gifts is that we don't quite know how to
put our love into words.

—Unknown

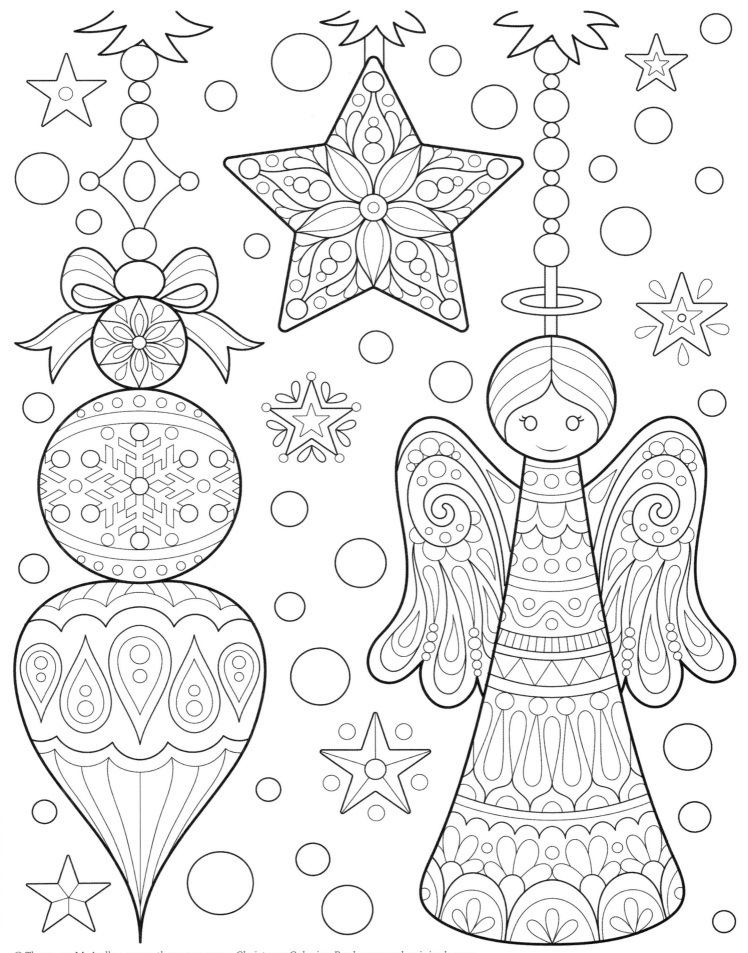

Christmas Day will always be
Just as long as we have we.
Welcome, Christmas, while we stand
Heart to heart, and hand in hand

—Dr. Seuss, *How the Grinch Stole Christmas!*

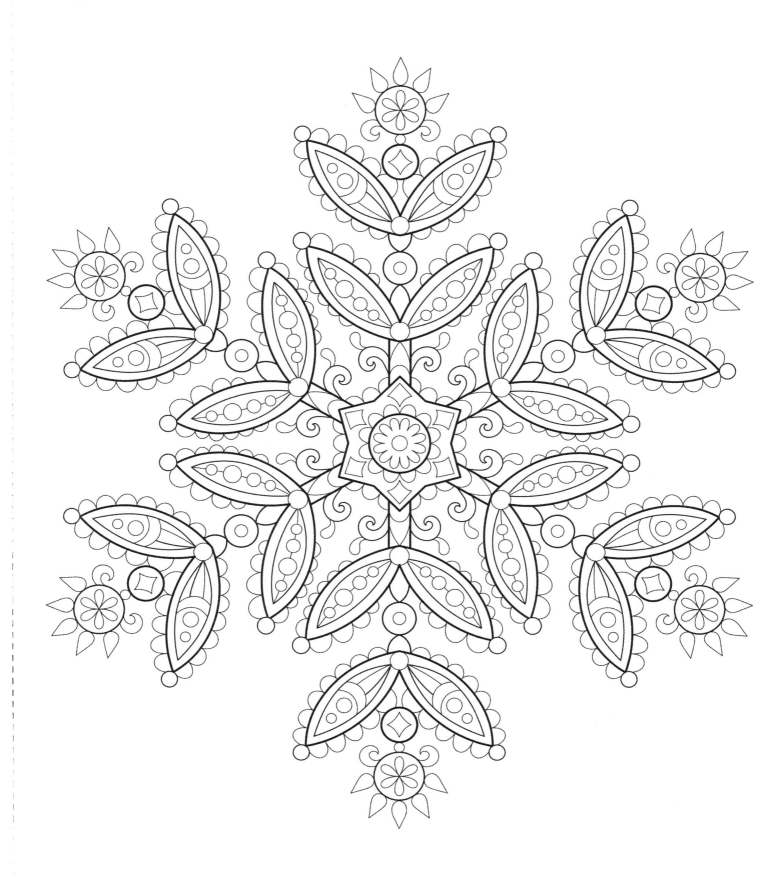

Like snowflakes, my Christmas memories
gather and dance—each beautiful,
unique, and too soon gone.

—Deborah Whipp

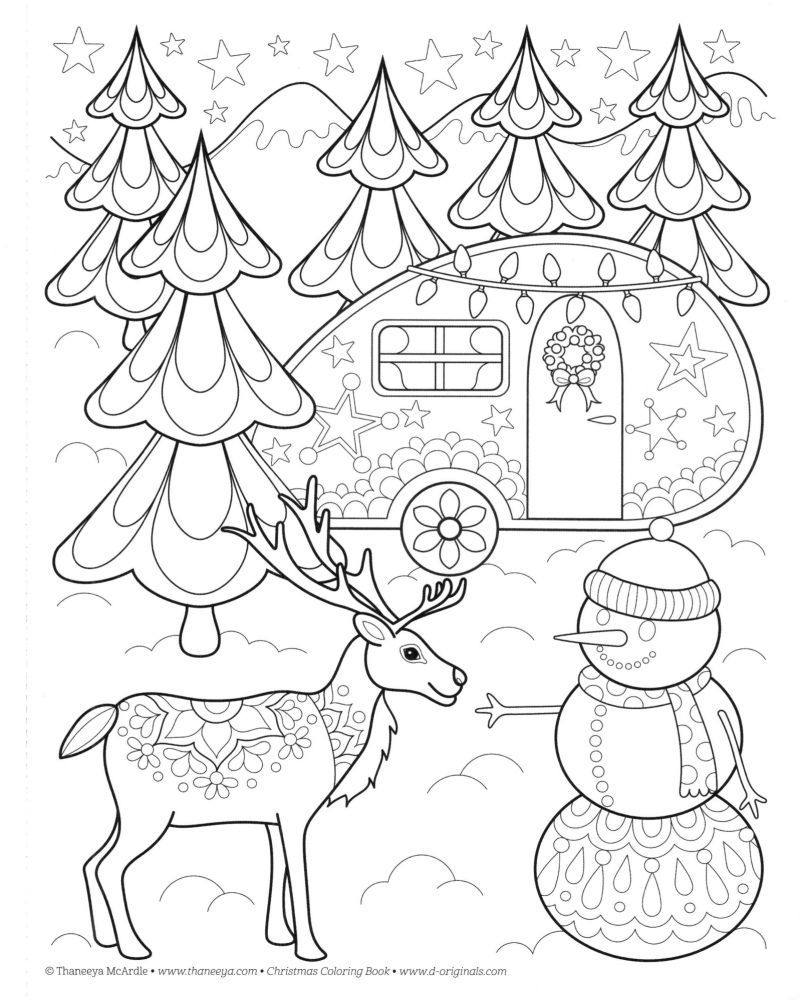

There are no strangers on Christmas Eve.

—Adele Comandini

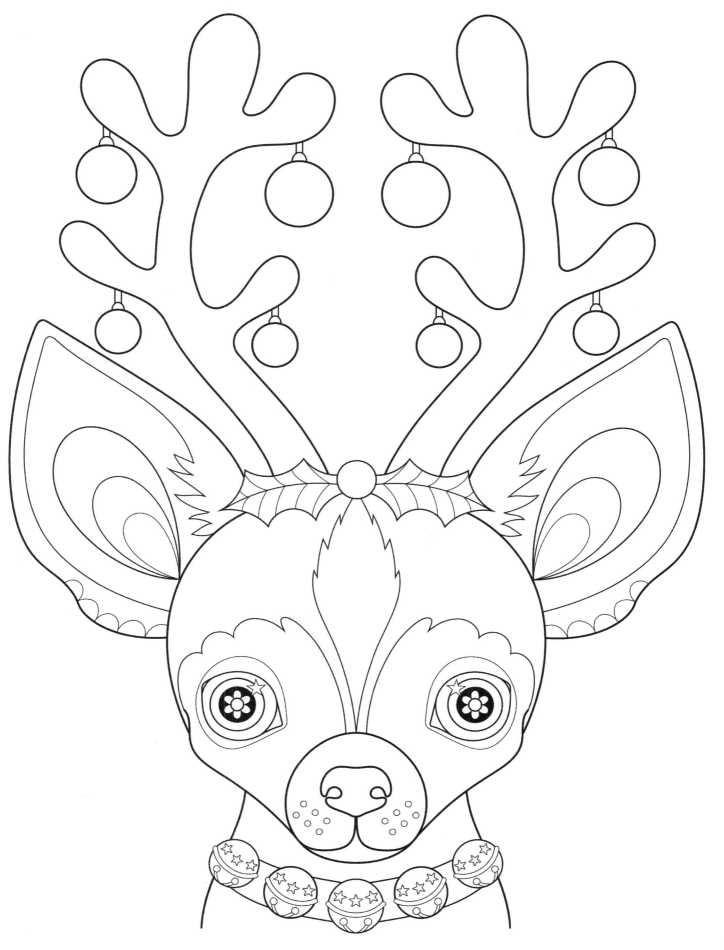

Merry Christmas to all and to all a good night!

—A Visit from St. Nicholas ('Twas the Night Before Christmas)